THE ENCHANTED LIGHT

THE ENCHANTED LIGHT
Images of the Grand Canyon

Photographs by Barry Thomson
Introduction by Steven Carothers

FLAGSTAFF : MUSEUM OF NORTHERN ARIZONA PRESS : 1979

THIS BOOK would not have been possible without the combined efforts and energies of many people. In particular, I am indebted to Ken Bacher for his dedication and faith in this project from its inception. Special thanks are also due Steven Carothers for his introduction and for some of the finest experiences I have known within the Canyon. For assistance in sequencing the photographs I am grateful to Ken Bacher, Lee Huskey, Katrina Mayo-Smith and Sam West. Production of the book was handled by Rick Stetter, Gary McClellan and Steve Gustafson of the Museum of Northern Arizona Press, Henry Flores of Imperial Lithographics, Stanley Stillion of Tiger Typographics, and Michael Roswell of Roswell Book Bindery.

Appreciation is also extended to Merrilee Caldwell, Margaret Erhart, Tony Gressak, Carolyn Holmes, Benson Hufford, Leif Johnson, Allen Naille, Tom Powell, John Thomas and Geoff Webster.

Finally, I wish to thank my parents for their support during the many years before the realization of this book.

Fern Mountain Ranch B.T.
October, 1979

IN ASKING ME to write the text accompanying these photographs, Barry Thomson gave me the opportunity to explore a new realm of the Grand Canyon's influence on my life. As I encountered these reflections, many previously cloistered feelings were forced to the surface of my consciousness, and for this I am grateful.

Although I shall never understand how, Peter Winn once led me to a special communion with the Canyon, then taught me how to survive its whitewater. My friends Lorenzo Stevens, Tomás Olsen and John Running shared with me their feelings, and in so doing, added direction to mine. My young son, Cooper, played quietly by my side throughout the entire manuscript preparation. His company was appreciated, his quiet was wonderful. And special thanks are due Anne Slobodchikoff who removed much of the roughness from a near final draft, then left a little of her heart in its place.

Lastly, credit must be given to the dedicated men and women of the National Park Service, who have labored through the years, often against substantial pressures, to protect the environs of Grand Canyon National Park.

Bridge Canyon Camp S.C.
September, 1979

THE IMAGES PRESENTED throughout the pages of *The Enchanted Light* represent a pictorial essay of portions of the Grand Canyon few have been privileged to visit. The artist's rendition of these canyon profiles, his patient searching for the exact combination of stone, water, light and form are all unique reflections of Canyon time and space—reflections that have been captured here alone.

While a few of the more sublime images of the Canyon reflect fortuitous rim-side encounters between the watchful artist, his camera and the ephemeral shafts of penetrating sunlight, it is impossible for those not familiar with the wilderness nature of the Grand Canyon to immediately appreciate the amount of human effort that has been expended in the Canyon backcountry during the compilation of this work. Many of the photographs are the rewards of difficult winter backpacking forays where the weight of precision equipment, added to a pack already heavy with the rudimentary necessities for survival, was a constant source of discomfort. Several of the scenes contained herein were captured only by swimming deep and icy pools, or by scaling exposed limestone and sandstone faces—always encumbered by the precious camera gear. Though these occasional hardships were the source of pounding apprehension and sometimes pain, they were simply assumed and truly enjoyed requirements of the work at hand. Many of the more remote hideaways and little-known side canyons were accessible only by river, and it was during one of these whitewater runs through the 277 miles of the Colorado River that I came to know and appreciate Barry Thomson and his desire to communicate a special feeling for the Grand Canyon.

There is more to these photographs than technical and artistic excellence. This became obvious to me when I had the opportunity to watch Thomson search out his subject during the events preparatory to the actual film exposure. More than once I was a participant in the process, steadying a precariously placed tripod while especially difficult compositions were being selected. It was during one of these work sessions in upper Elves Chasm, a lush and beautiful cleft of limestone and travertine grottos, when I recognized that we shared similar feelings for the totally awesome nature of this place called Grand Canyon. The sincerity with which he clearly stated his intention to communicate, through his photography, feelings of intimacy with the spirit of the Canyon assured me of his convictions. It is surprising the ease with which relationships flow once you have recognized some of your own madness in the reflective twinkle of a companion's eyes. We spent a lot of time on the remainder of that trip trying to define and encapsulate our "romantic" notions about the Canyon country and the wilderness it embodies. What is it, we wondered, about

all this rock, color, space and excitement that causes us, both mature professionals who should "know better," to seriously discuss, in what can only be identified as spiritual tones, the role the Grand Canyon plays in our lives?

For years I have been slowly waking to the infectious stimulus of a Canyon adventure. With each return I experience an increasing intensity of awareness, both of the Canyon and of myself, and a cumulative joy that is always waiting. Now, as we explored and photographed some of the most beautiful of the Canyon's hidden shrines, I made an attempt to articulate my feelings into prose while Thomson recorded his on film. It has been more than difficult to capture my reactions to the Canyon with words—to say that it is beautiful, powerful, spiritual or moving, a few of the descriptive nuances that flash before me, does nothing to clarify the nature of what I wish to express.

As a scientist, indoctrinated from my youth with a passionate respect for data, controlled experiments and the beauty of the scientific method, it is not without a great deal of timidness that I pen such phrases as "the feeling of the Grand Canyon" or "communication of emotion." An attempt to describe a feeling, especially for a marvel of natural creation like the Canyon, can never be adequately expressed by language alone. Attempts to record a point in time filled with such emotion as the Canyon evokes in me must always fall short of a satisfactory expression. As I struggled with this realization, it was with the thought that perhaps the words I sought would be better left for more rational treatment by experiential psychologists, or even to the esoteric wandering of the mystic. The psychologist I have no pretensions of imitating, nor have I completely succumbed to the natural instincts that drive my primal core and "returned to nature." Simply, it has become more and more difficult for me to contain the excitement that comes from realizing the ease with which important steps in the never-ending search of self-awareness may be taken in this wilderness environment.

Throughout the past twelve years, much of my interest and energy has been directed toward extensive biological research projects between the rims of the Grand Canyon. During those years I have roamed the rocky slopes, logged hundreds of miles on established trails, climbed into the hidden side canyons, spent hours in reflection at the sacred Hopi shrines, and run the Colorado River scores of times. In recent days I have slept beneath the protective mantle of Canyon sky for at least one-third of every year. As a canyon naturalist, I am usually far more intrigued by the ecological

adaptations of rattlesnakes, desert plants and the humpback chub than with the permutations of Man's responses to the great out-of-doors. Yet, in the course of my journeys, I have observed strangely similar patterns of behavior and feeling in others of my species, who, through accident or design, have had the opportunity to experience this canyon wilderness.

Almost without exception, the people I encounter within the depths of the abyss are, at that place and time, delightfully content. I cannot even begin to count how many times I have heard the statement "I have never felt so good." This simple testimony is so sincere and common down in the Canyon that I think it deserving of some careful consideration. The type of experiences which I relate occur over a period of several days, if not weeks. These adventures include both strenuous backpacking excursions and the idyllic flow of Colorado River expeditions. Extreme privation and suffering need not be a part of these experiences. Within the confines of exhaustive logistical preparations designed to minimize the very real threats of the raw environment, exposure to the wilderness is as gentle as circumstances will allow, and the traveler has the opportunity to feel the Canyon in a relaxing, although sometimes physically and emotionally demanding, way.

For an interesting contrast to the leisurely Canyon experience I have just described, one can spend an afternoon in July or August a mile or so down a heavily used inner canyon access route. The Kaibab and Bright Angel trails steeply traverse the mile-deep chasm crawling from the South Rim to the River in seven to nine miles of grueling, nearly shadeless terrain. If you watch the facial expressions worn by the day hikers or those wonderful martyrs who endure hours of lurching through the Canyon astride a self-righteous mule, you will witness little contentment. Most of these visitors are undergoing a test of strength while facing the Canyon for the first time. Although they will later tell of a truly unforgetable experience, it will more likely stem from memories of physical torment rather than a mellowing of their psyche. In the first place, few bodies are sufficiently seasoned to the saddle or the trail to enjoy the ordeal one must go through on the steep slopes in the summer sun merely to move from one water source or resting area to another. Again, it is beyond the capabilities of most mortals to experience, much less comprehend, the physical, visual or spiritual significance of the Grand Canyon in a single day's visit.

Every now and again, some desperado will zip up and down these trails, painlessly humming something like "sublimity unequalled on the hither side of paradise," a Canyon song that can be credited to our first great Colorado River explorer, John Wesley Powell. Chances are this happy hiker has been here before, knows what

to expect, how to enjoy it, and cannot think of anywhere else he or she would rather be. I know people from all walks of life, the infirm as well as the strong, the immature, the aged, the demented and even a few "normal" souls, who firmly believe that everything is better in the Grand Canyon.

I would like to make an attempt to describe, and if possible, explain the nature of the captivating influence the Canyon country has on the lives of those who touch it and yield to its enchantment. I am reaching out and exploring this phenomenon from the vantage point of *knowing* that there is something special here, and that this specialness has a tangible influence on the human spirit. In my own Canyon explorations, as I listen to, live with, and sometimes touch both the wilderness initiate and seasoned *afficionado*, I have come to the conclusion that if it is contentment of the human psyche we ultimately pursue, one need go no farther than these rugged and unspoiled habitats where the indefinite boundaries of space and time are so perfectly clear.

I have previously alluded to a certain "spiritualness" that the traveler can find during a Canyon journey. It is important now to arrive at the essence of this emotion and describe it in terms that are less esoteric and more coherent. In an attempt to understand my own involvement with this wilderness and the sensory fulfillment I experience there, I must wonder: did I come to the Grand Canyon years ago already emotionally primed for capturing a new awareness, or once there, did I become subject to cumulative mystical experiences contained within the Canyon itself? And have these experiences expanded my reason while confounding previous assumptions that were so securely rooted in the scientific method and all for which it stands?

First impressions might indicate that we need not rely on the existence of a mystical or spiritual dimension to investigate the nature of what happens in the minds and bodies of Canyon enthusiasts during a wilderness journey. Indeed, I will develop a rationale that accounts for most of these feelings by pointing out that when the human animal is *not* in the wilderness, it is actually being deprived. Yet, I have been in many a wilderness situation outside of the Canyon country where, though the areas may be wonderfully pristine and beautiful, I am not impressed with the same sense of spiritual awareness that is so easily captured in the Grand Canyon.

When I speak of the "spirit" of the Canyon with which our wilderness travelers become intimate, I am referring to a feeling that I believe is a simple outgrowth of the human animal's response to being placed in something akin to its natural habitat,

a sense of coming home. What I cannot resolve is the seemingly unique intensity of this response in the Grand Canyon. Is it the striking immensity and boldly displayed supremacy of nature that creates the special attraction and captivation of this place, or might there really exist an ultra-dimensional power there that alters the travelers' awareness once they are exposed?

The ancestral Hopi Indians inhabited northern Arizona for at least a thousand years before European man ever dreamed of the existence of a place like the Grand Canyon. The Hopis today are convinced of the Canyon's sacredness. To them, my concern for the presence of powers outside the dimension within which we usually reside is far from preposterous. In the religious structure and mythology of the Hopi, the Canyon country plays a profound role in the order of life. As related in the legends of these enduring people, there is no place quite like the Grand Canyon for encountering spirits, both good and evil. For hundreds of years, the heavy salt deposits that seep from the Tapeats Sandstone at river level near the mouth of the Little Colorado River were a primary source of salt. The ordeal required of the Hopi men to reach the salt caves from their villages had deep religious significance and included days of trekking through some of the most inhospitable country imaginable. Though the physical exertion was substantial, it was the presence of all the deities along the route that kept these courageous believers in a constant state of excitement. This firm belief in *real* spirits by a group of people who have lived with the Grand Canyon for so long, and the occurrence of some rather terrifying encounters with the unknown that I have witnessed while visiting ancient and sacred shrines, only intensifies my confusion. This rational disorientation is compounded by the fact that as I wander through the experiences of adult life, it is continually necessary to discard the order of the world that my teachers saw. Thus, while searching openly for explanations to confusing natural phenomena, I have not been able to gather sufficient evidence to discount the existence or the power of the Hopi spirits. The Grand Canyon has offered me the opportunity to discover a sense of freedom and completeness that my prior experiences had not made possible. A search for this awareness, and the capacity to accept it, are innate within the human animal. Beyond this, the absolute magnetism of the Canyon is too powerful to be merely a product of Man's nature. Heretical suspicions and a sense of caution compel me to admit that this magnetism may be created by more than just a little magic, there, in the Grand Canyon environs. No matter how convinced many of us are with the reality of a mystical influence in the Canyon wilderness, this belief must always be relegated to the realm of the inexplicable. Now we must move on to the empirical

reasoning that accounts for the spontaneity of a smiling peacefulness all too available to the Canyon traveler. The feelings of deep satisfaction and contentment expressed by my companions during a Grand Canyon journey are unleashed from a very primal level.

Recent scientific and popular literature beckons us to recognize the influence of human origins on our contemporary behavior and physiological responses. We are informed, in a very convincing manner, that our sexual passions, penchant for violence and quest for material possessions are part of a natural behavioral scenario. The emotional "rush" we experience during periods of extreme fright or anger is another of our atavistic possessions: hormones surging to the aid of strategic metabolic processes that prepare the body for physically demanding retreat or attack. These characteristics were all being selected for as adaptive traits some time before mankind made the transition from the trees to the moon. Many of our drives are left over from the days when primitive man responded to the environment without the benefits of language, tools and fire. The capacities for not only surviving the wilderness, but finding an elusive fulfillment therein, resides beneath the intuitive framework of each and every one of us.

It was during the era several thousand years ago, at a time when early humans were omnivorous and opportunistic predators, that the human animal's intellectual capacity began to flower. With the development of language, the discoveries and mistakes of one generation became a functional basis of knowledge for the next. Hence, the pathway was laid for the rise of the elaborate technological and cultural society within which we find ourselves today. Intellectual progress has been astonishingly rapid. The innovations of the last two hundred years alone bear mute testimony to the efficiency with which the intellect of Man has allowed us to make quantum jumps away from our animal origins and instincts.

For many years, it has been recognized that the bodies within which modern men and women reside are biologically equipped for a lifestyle that is virtually extinct in our society. In an organism as slow to grow and breed as Man, the evolutionary forces of natural selection have not had sufficient time to keep the body in synchrony with the rapidly developing intellect. Today the human species is operating in a technologically advanced world where an efficient body is a luxury, not a necessity. In fact, as we face the dictates of present living conditions, the requirements and responses of our bodies often interfere with certain aspects of the life we pursue. There are entire sub-disciplines of anthropology and modern medicine that

6

are dedicated to the study of the mental and physical repercussions of this unique dichotomy. Simply, computer technicians, farmers, bankers and biologists all go about their lives constantly repressing the animal that begs to get out and wander the wilderness with others of its kind. We spend much of our lives tightening the cultural and societal chains with which our ancient but powerful notions are firmly bound. Then we wonder at the strange physical and mental aberrations our bodies display as they cry out in discontent.

An exposure to the Canyon has a somewhat different emotional significance to each traveler, but in taking a long journey through the wilderness of the Canyon country, one has the opportunity to allow inherent capacities for interacting with an untrammeled nature to surface. Becoming aware of the full repertoire of sensory stimuli with which we are equipped, and utilizing these survival tools while in the wilderness, constitute an experience that is simultaneously revitalizing and expanding. We are adapted to live in constant communication with the elements of nature, including both the pleasurable and threatening. Once these adaptations are recognized, nurtured and given free rein, the traveler becomes aware of a new dimension of confidence and well being.

In this "modern era" where normal living conditions are some distance from the wilderness, a lengthy exposure to the wild can have a remarkable influence on one's body and mind. The wilderness greets its invaders with some special and contrasting conditions. Initially, there is the daily physical confrontation with an environment devoid of the usual comforts. Sleep arrives only a little behind the twilight after a full day of exposure to whatever climate the Canyon might choose to provide. Given several days of adjustment, our travelers become aware of an exciting invigoration they might never have felt before. Superimposed on their physical exertion and the strikingly beautiful surroundings to which the Canyon enthusiasts must respond are two very powerful forces. One is a sense of freedom; the other, a sense of fear.

Reducing the components of the wilderness journey to their basic and unique elements, I have found the pervasive feelings of freedom and fear to be the causative factors generating contentment and a developing self-awareness. As a Canyon journey begins, regardless of whether the travelers attach themselves to a backpack or a life jacket, the initial sensation is the same. Step off the rim or onto a raft, and everything considered to be of critical importance only minutes before becomes suspended in another world. A delightful sense of freedom invades the spirit almost

immediately, releasing it from the artificial trappings of day-to-day existence where all too often the only exposure to nature is a daily hike from city parking lot to office or factory door. For the traveler, time ceases to progress in the normal sense. The past becomes a shadow of its former self, and unfinished business or difficult personal situations cease to command any great importance. Immediate contact with the outside world is all but impossible. Thus, the present consists of the visceral excitement that comes with being separated from the protective world above, and with the necessity of confronting immediate events in the new surroundings. Anticipation of the future extends no further than the next meal or campsite, unless, of course, you have been on the wilderness route before and can nervously look forward a few days to a particularly severe rapid or intimidating climb. At this point enters the sense of fear.

I didn't know what "scared" was or the intensity with which my being would respond to this emotion until I faced some of the cliffs and rapids of the Grand Canyon. Years after my first confrontation with an especially terrorizing swim through the holes and standing waves of a major rapid, I came to realize that one of the main attractions that the wilderness held for me was the possibility that it could quickly separate my body and soul. Each day I am in the backcountry or on the River, I know that unless my decisions and attention to every detail are unerring I can be thrashed and tortured by the very environment within which I choose to live. The wilderness can be exceedingly ungracious to those unprepared or unaware. When I stand above a major rapid at low water before taking my boat through, or inch along a narrow ledge with what might as well be infinity below me, my body is reacting at full capacity; I could just as easily belong to another time and be planning an attack on a woolly mammoth or an escape from the hunger of a sabre-toothed tiger. The absolute exhilaration created by finding myself outside of time, face to face with nature in all its most elemental aspects, including mortal danger, keeps my life on the edge of an emotional plane I simultaneously fear and savor. This combination of freedom and fear allows Man to exist in a world of satisfying simplicity and preoccupation with the present. The wilderness journey takes the traveler into just such a simple world, a realm where the past and future cannot influence introspection. If you meet yourself in the course of this journey, you have successfully loosened the bounds binding the intuitive animal within you, and as a result you face the wilderness with vastly increased capabilities. My experience tells me that these self-encounters are usually rewarding. The extent to which the

animal inside each traveler is unchained determines the level of impact the journey will have on his or her life. For some, the adventure will be little more than the relaxing sense of freedom that comes with a temporary release from responsibility. Others will remember a fantastic journey into the wild and into themselves, but one which they dare not take again. These cautious travelers allow their animal to surface briefly, but find the consequences of its total release impossible to reconcile. Then there are the very fortunate who find the journey to be a milestone in a developing maturity of emotion and changing life direction. For them, the Canyon wilderness provides everything that is meaningful. At trip's end, they return to their former lives only long enough to realize that there is a part of them now that must have the wilderness close by: the animal within can never again be permanently contained, and it must forage periodically. Frequently, these courageous individuals gather their belongings and return to the rims or the River. Once in a great while, someone will come to the Canyon in whom the animal is so firmly confined that all form of survival intuition is dead. On these people, the Canyon can have little or no beneficial effect, and they constitute a liability to themselves and those who must protect them. But for all the other travelers, the Canyon brings them into harmony with themselves to one extent or another.

The wilderness of the Canyon country is my natural habitat. The more I am exposed to its peace, its beauty, its inexplicable forces and especially the simplicity of life therein, the less tolerant I become of the life available in the capricious world of my alternate existence. Yet, simply knowing the quality of life available in the wilderness, and that the pristine wildland is there, keeps my emotions in balance and furnishes my life with deeper meaning.

Grateful I am to Barry Thomson for creating a wonderful collection of images of this indescribable place we both love. In the end, I still have not found the words that clearly portray the feelings we share with so many others. It is a personal expression, impossible to generalize; a statement unique to each Canyon traveler, and for that perhaps we should celebrate. With his monochromatic images in my hands, I can see the beauty and feel the freedom and fear we have experienced while searching for whatever compels a full life. I can hide within my alcove in this world above the Grand Canyon and let my spirit flow into and about the perfect scenes found in this book. With these photographs he has brought our intimacy with the Canyon out of the abyss. I can feel it, and my animal becomes restless as a result. I must be

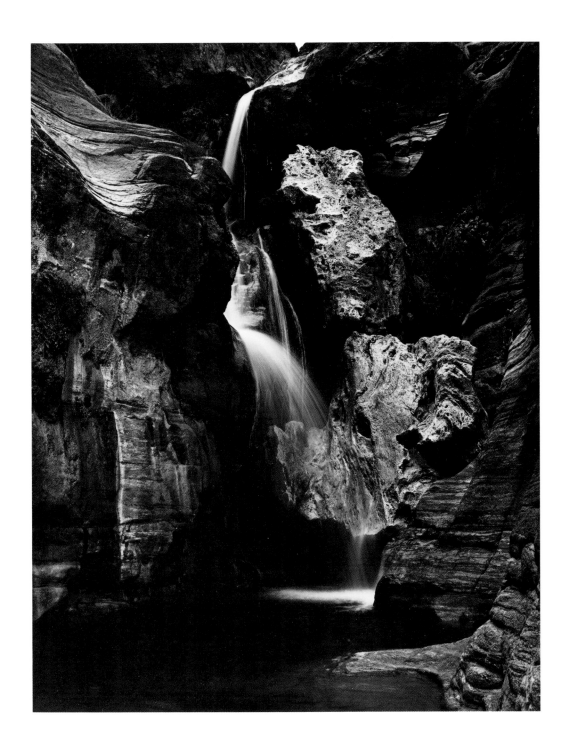

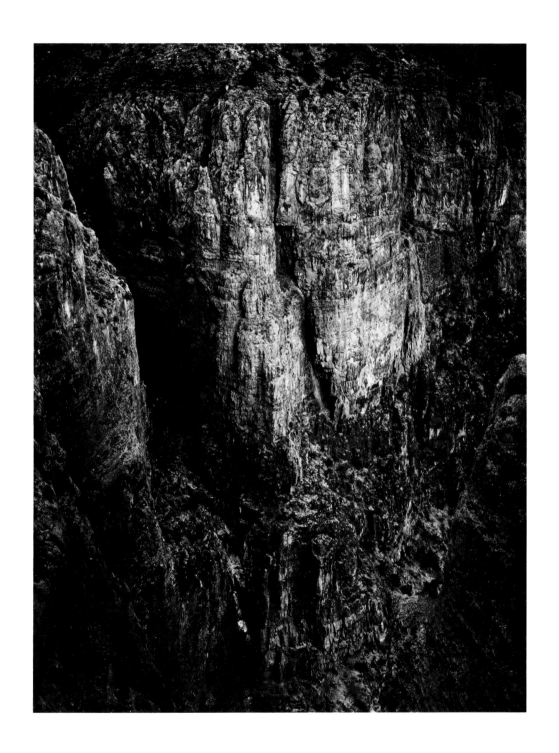

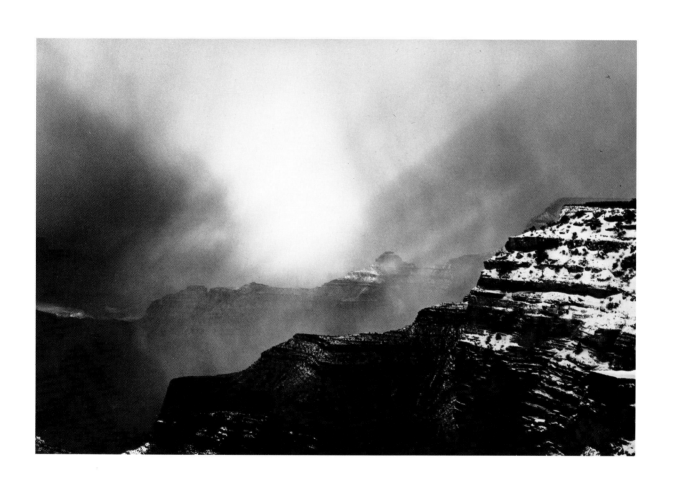

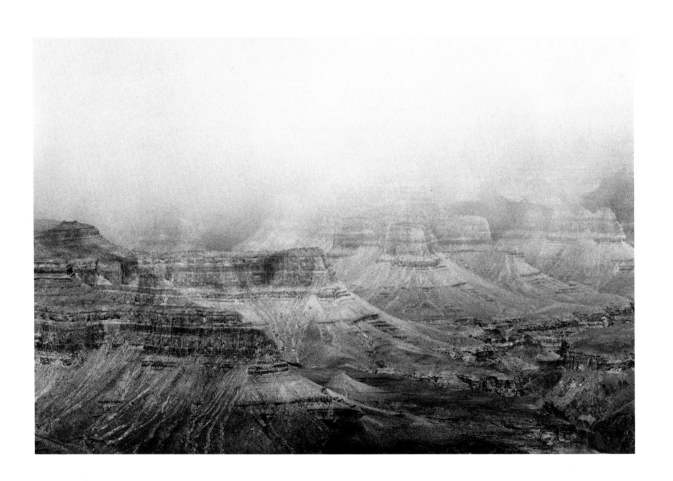

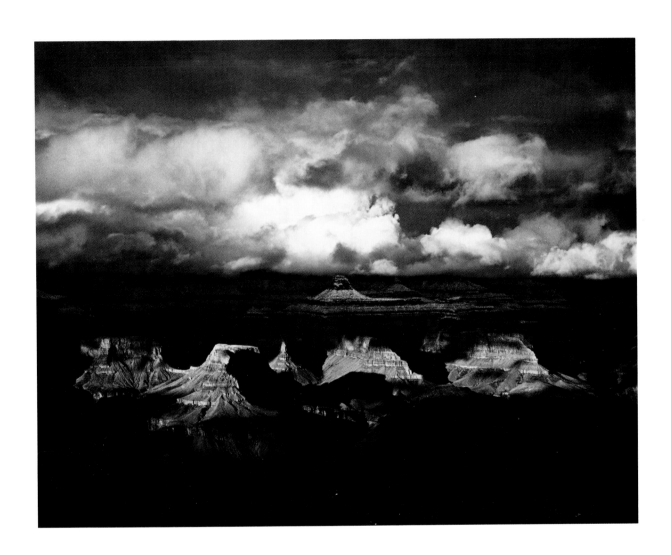

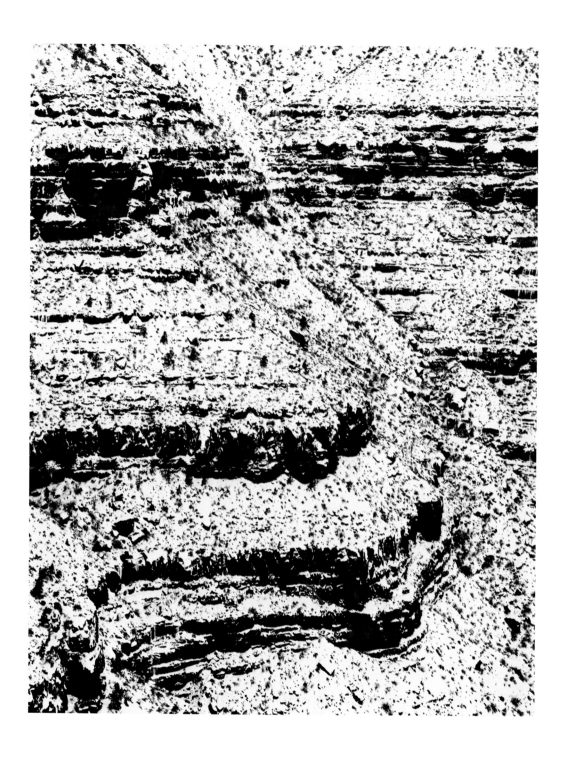

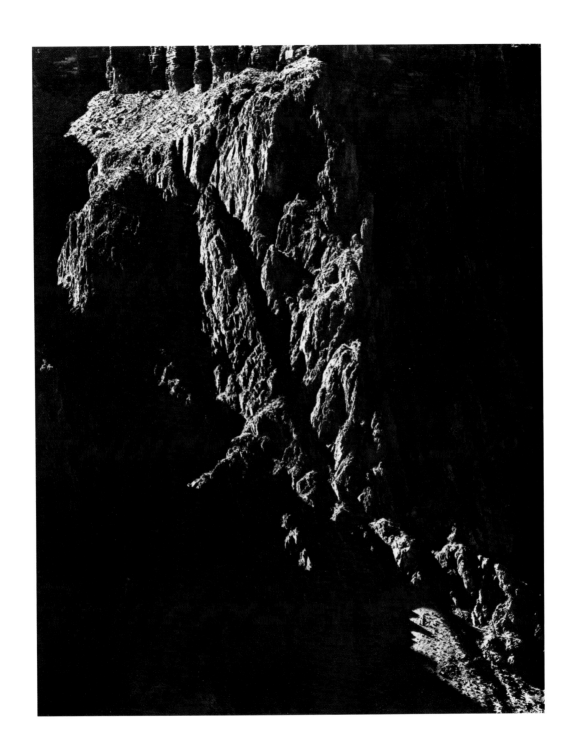

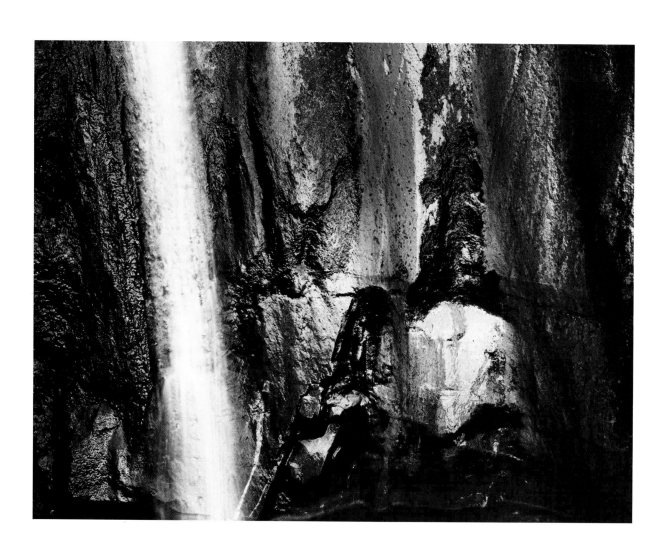

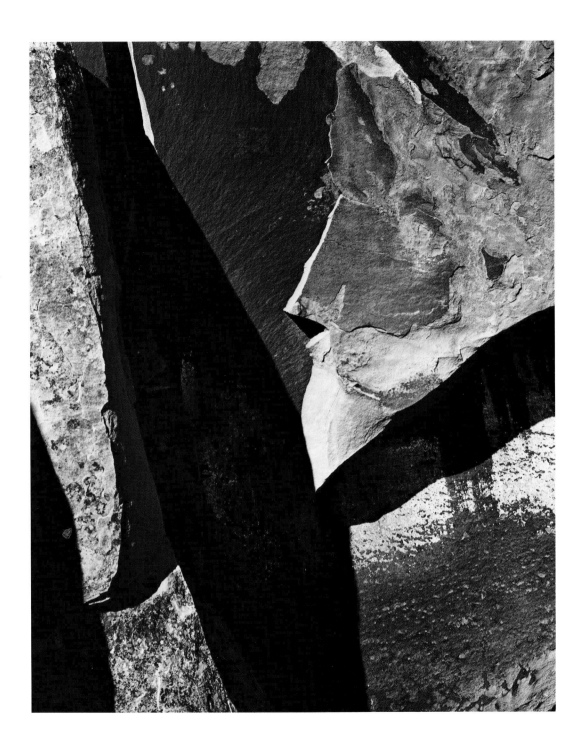

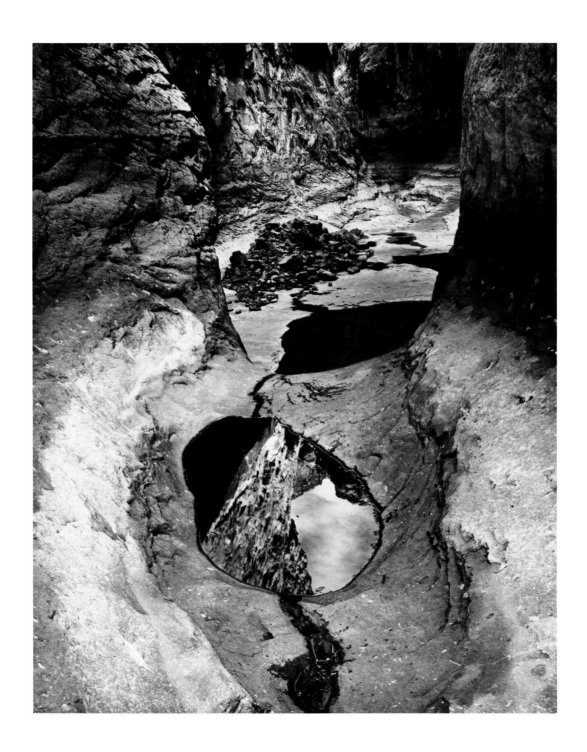

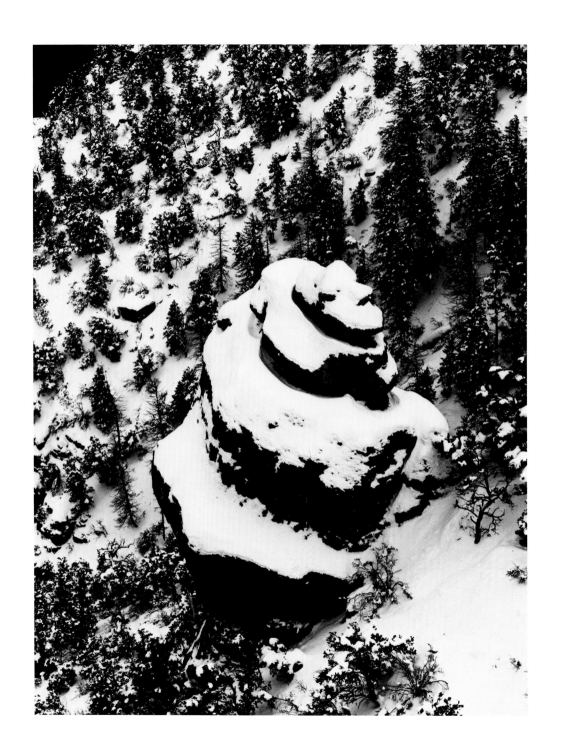

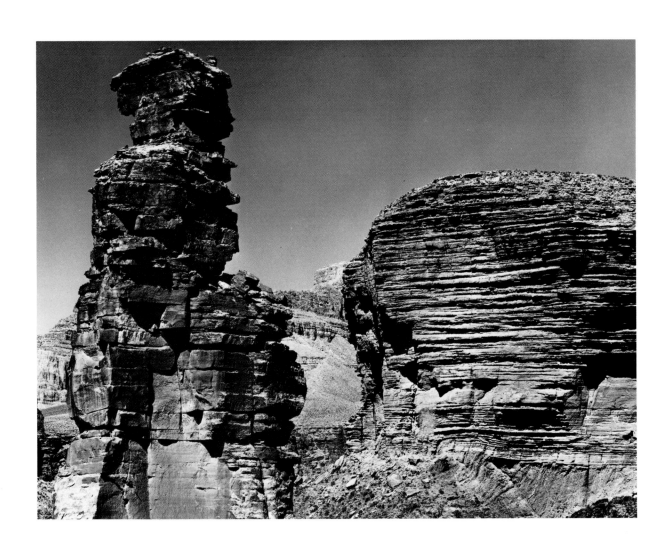

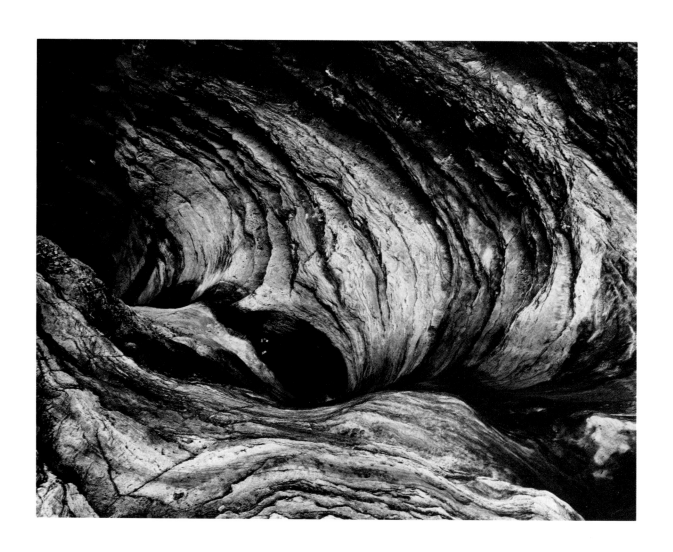

28

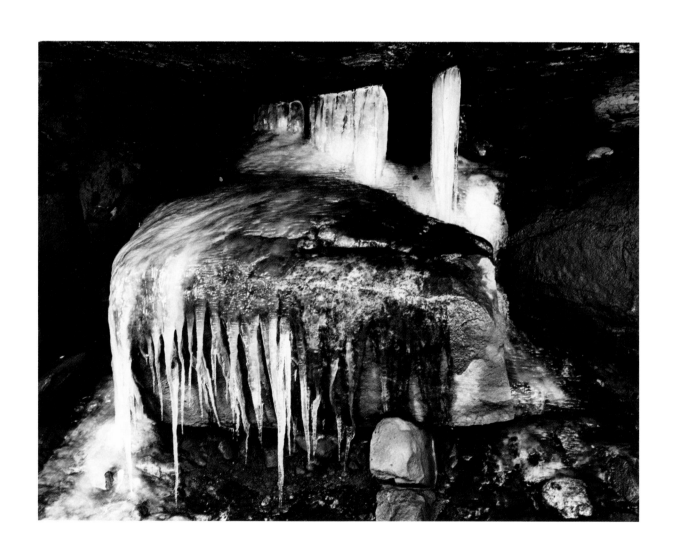

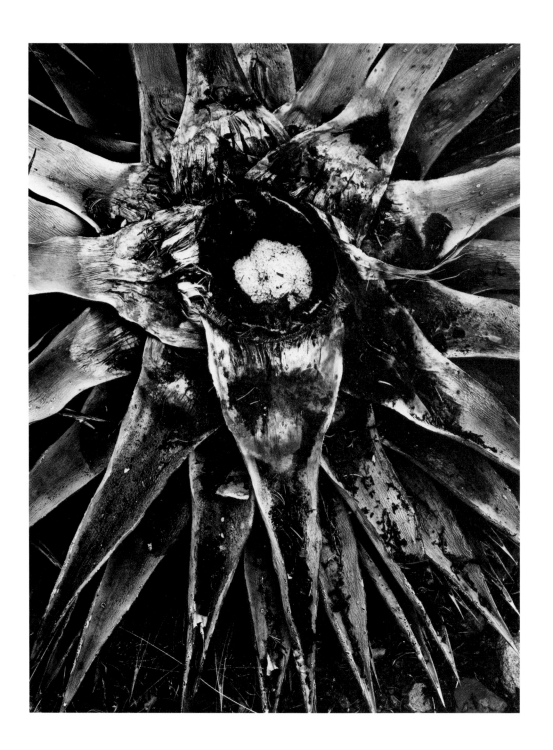

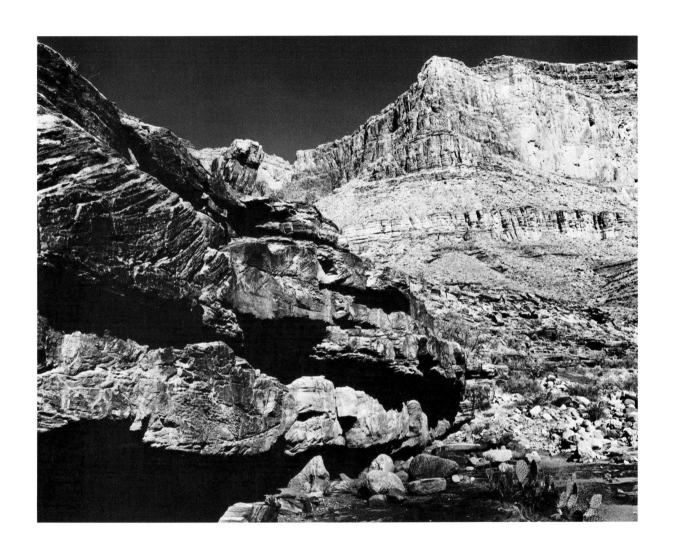

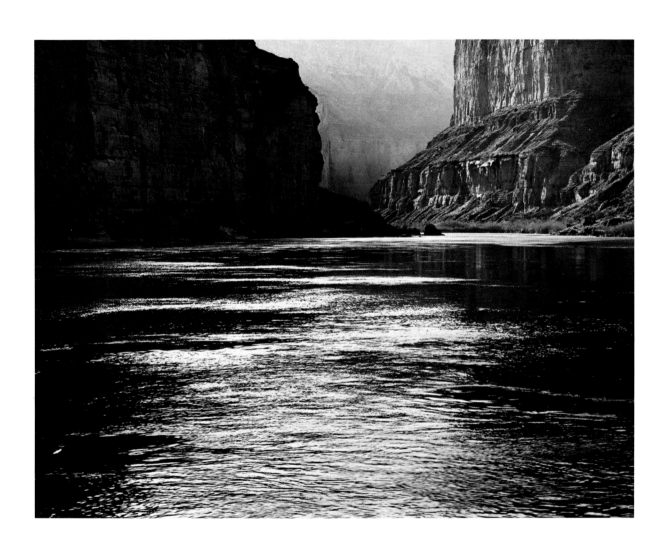

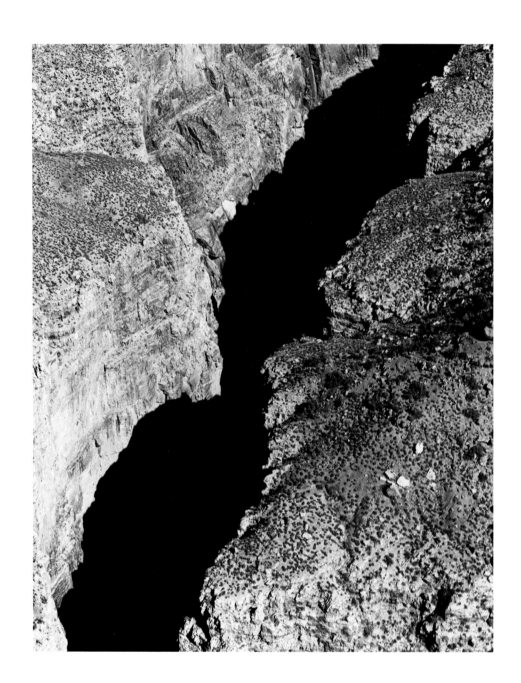

34

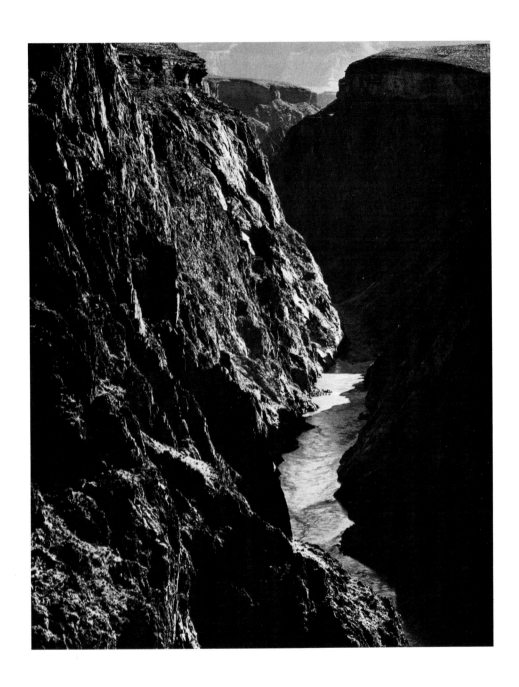

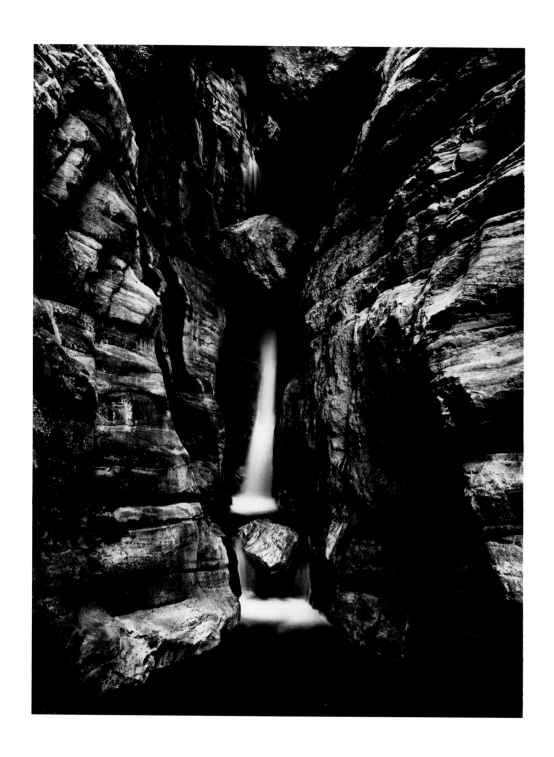

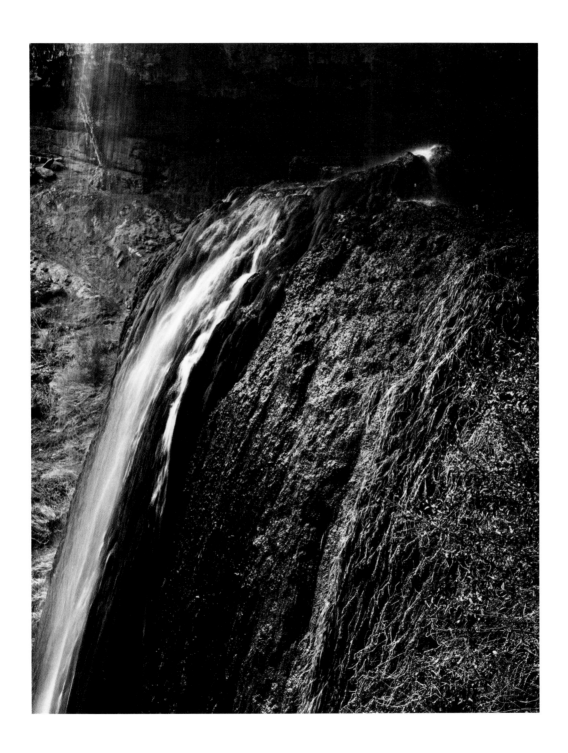

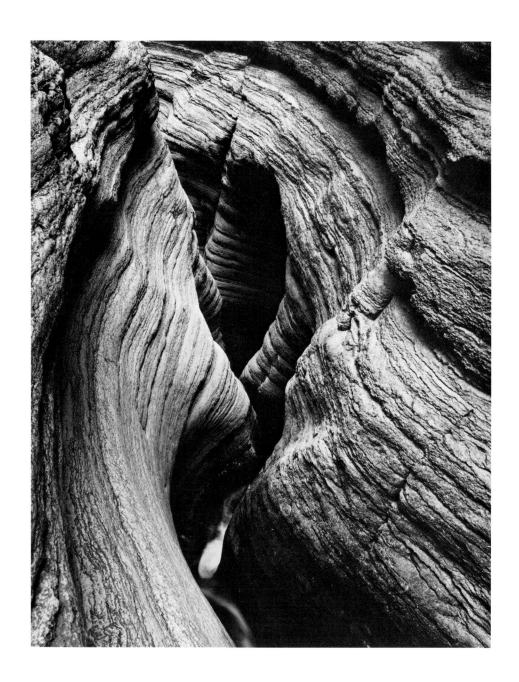

38

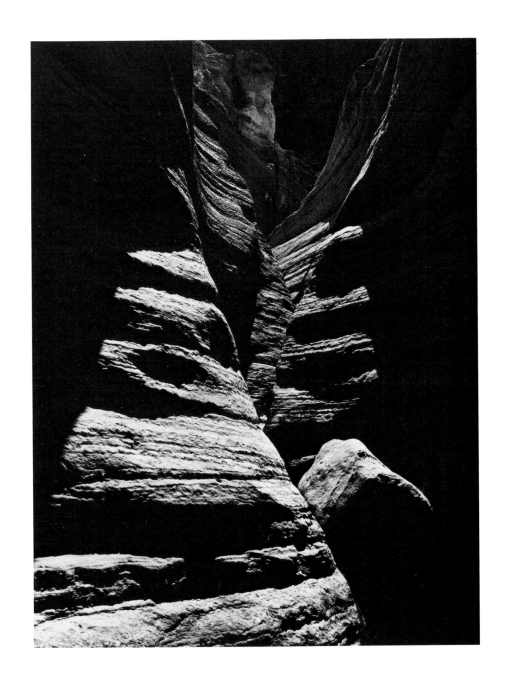

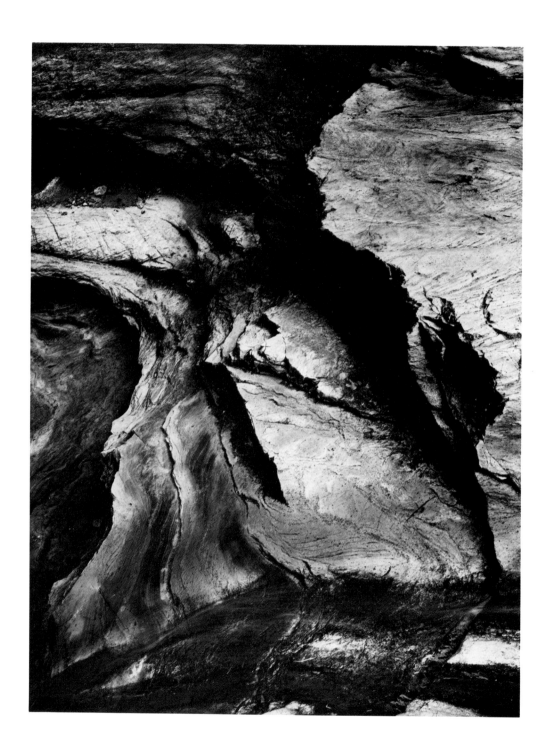

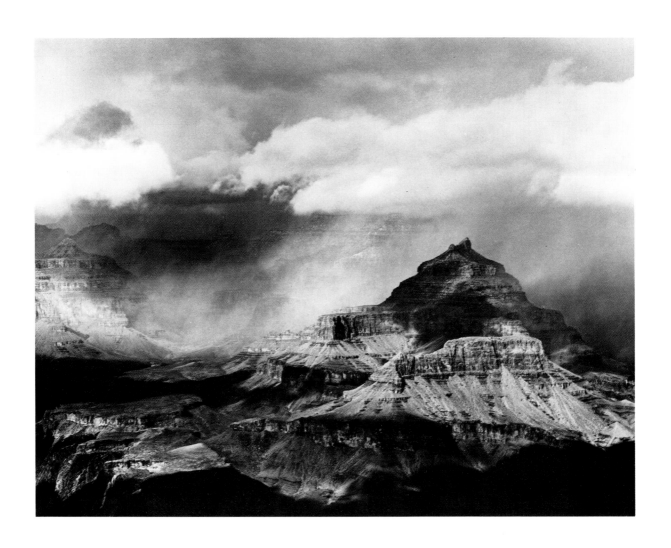

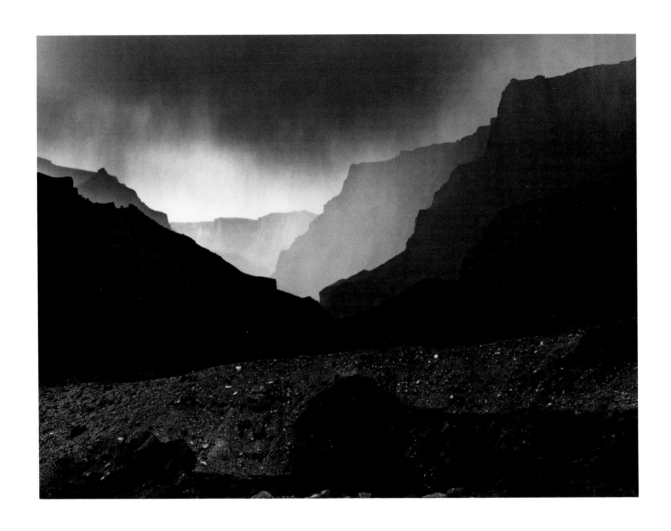

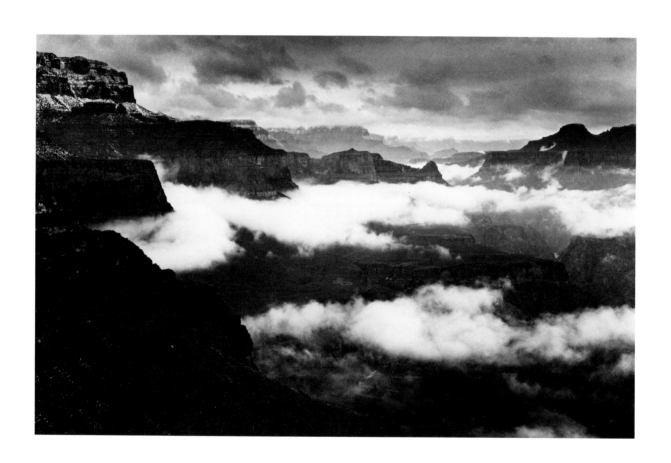

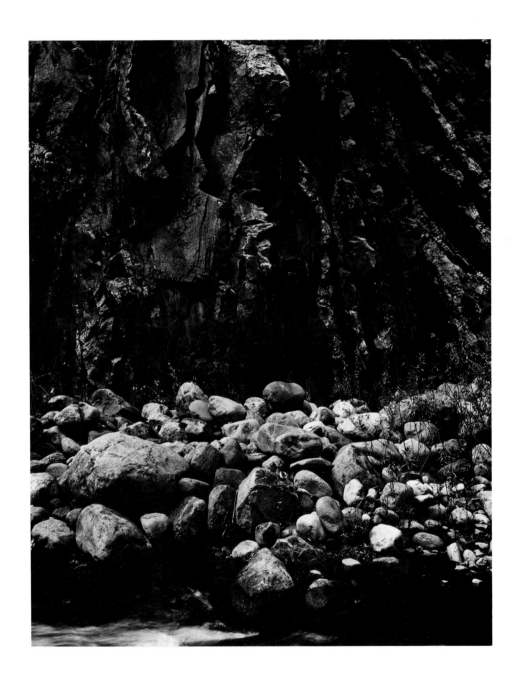

45

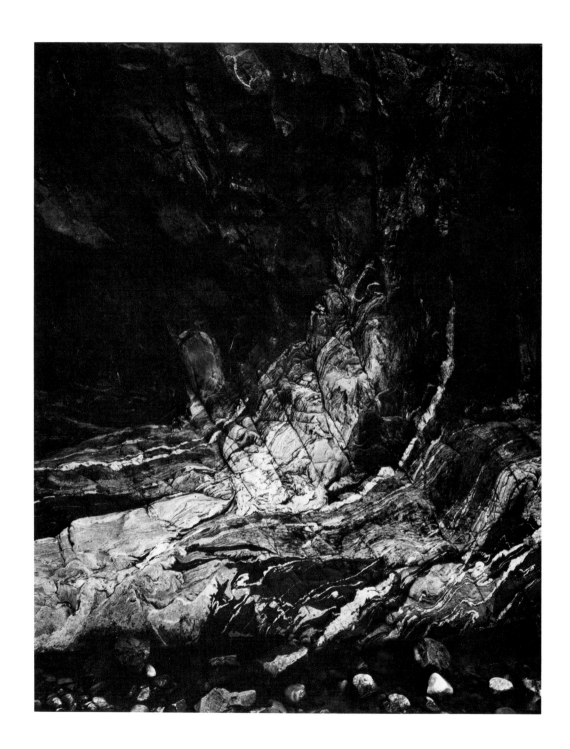

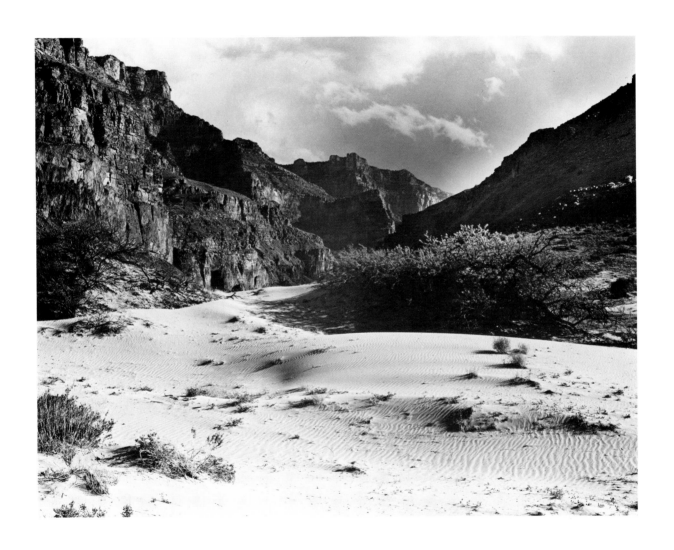

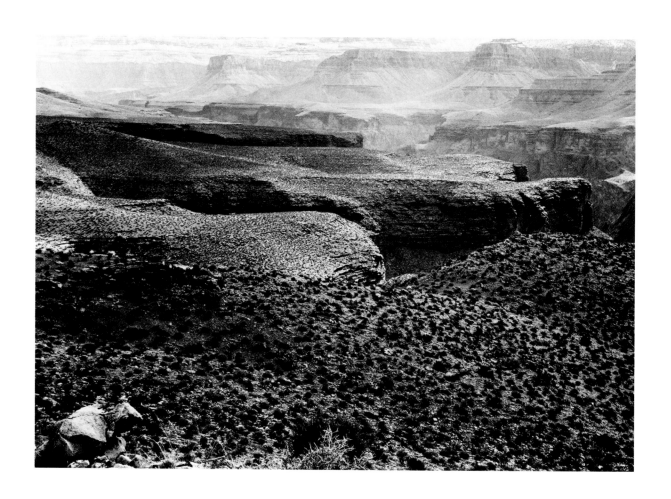

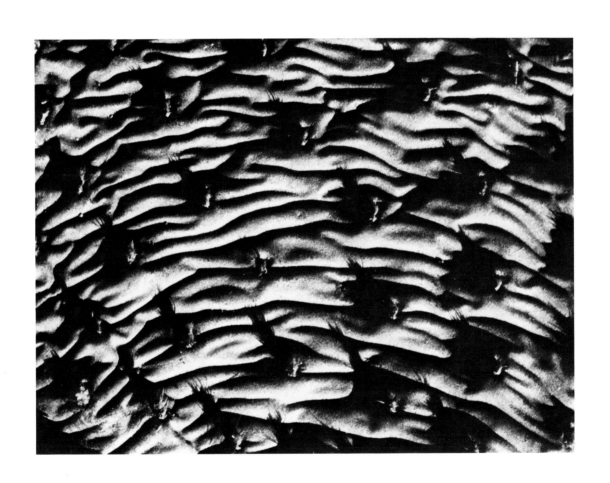

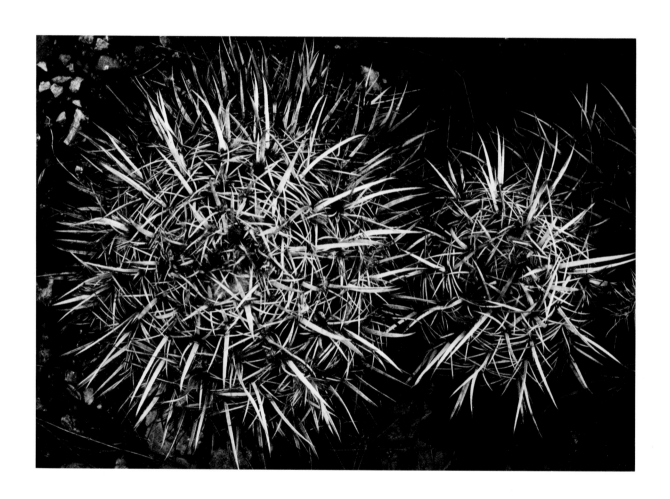

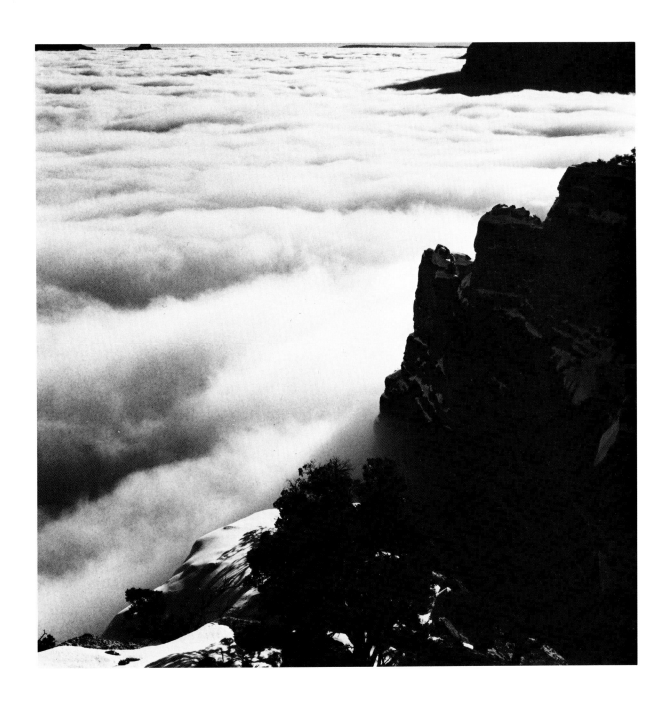

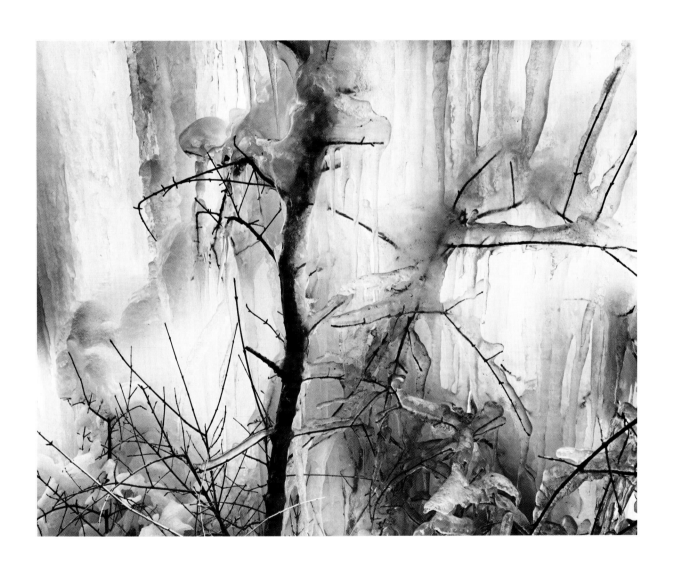

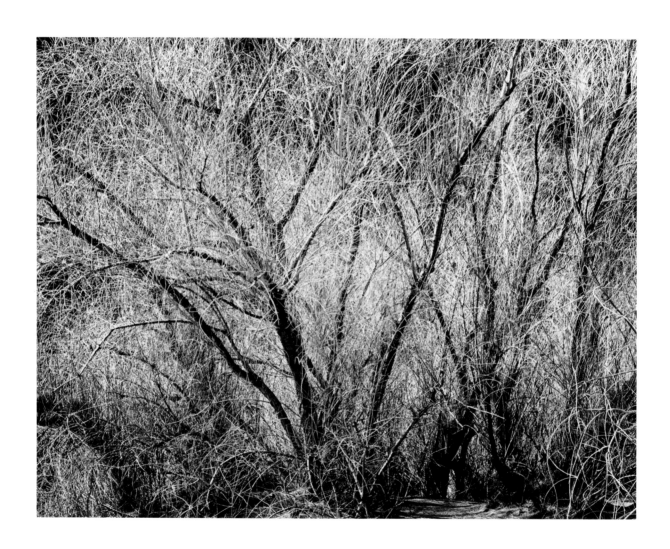

54

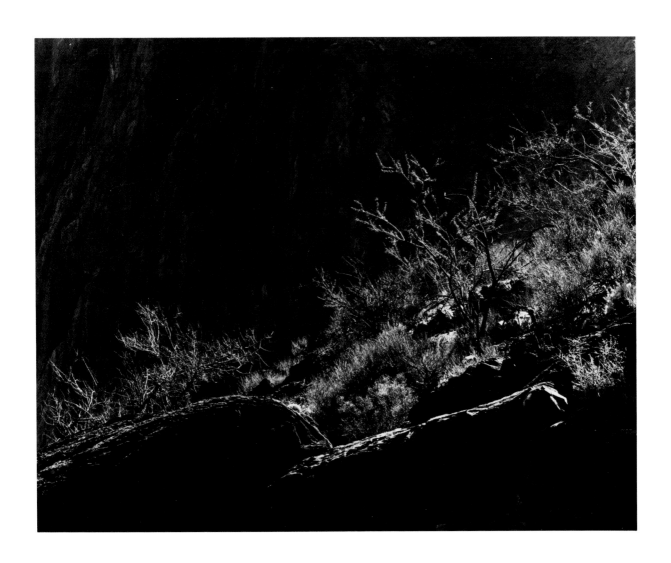

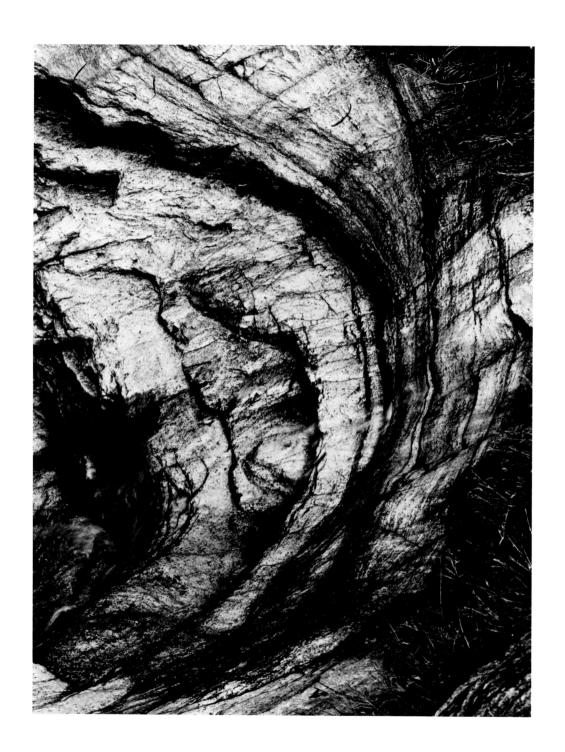

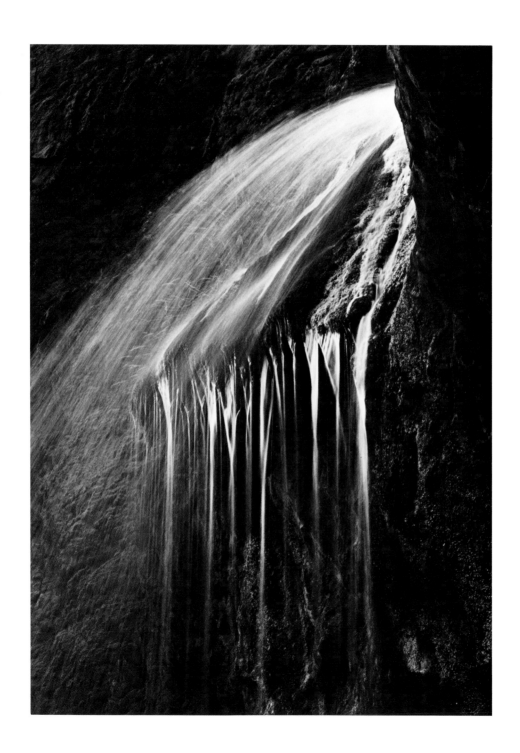

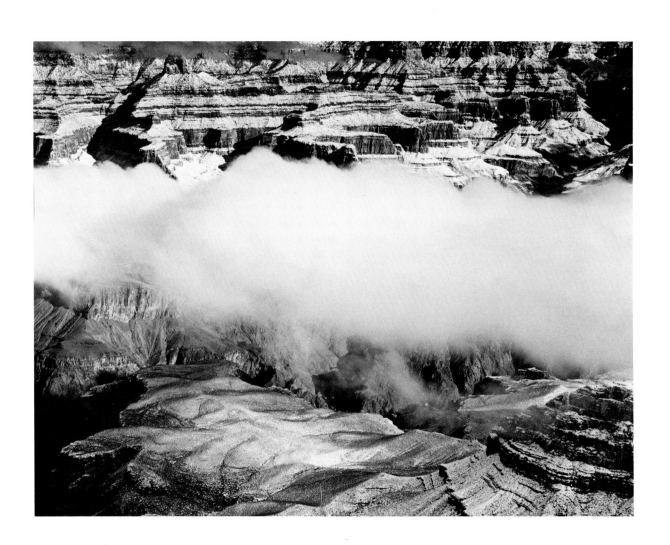

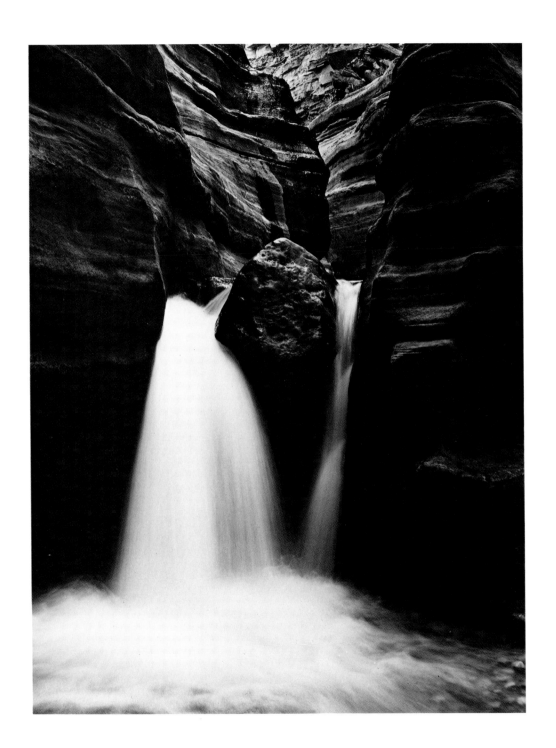

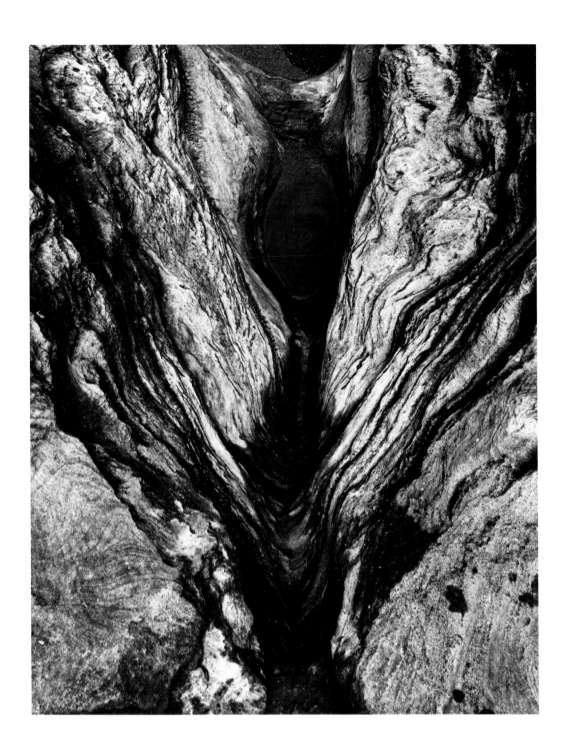

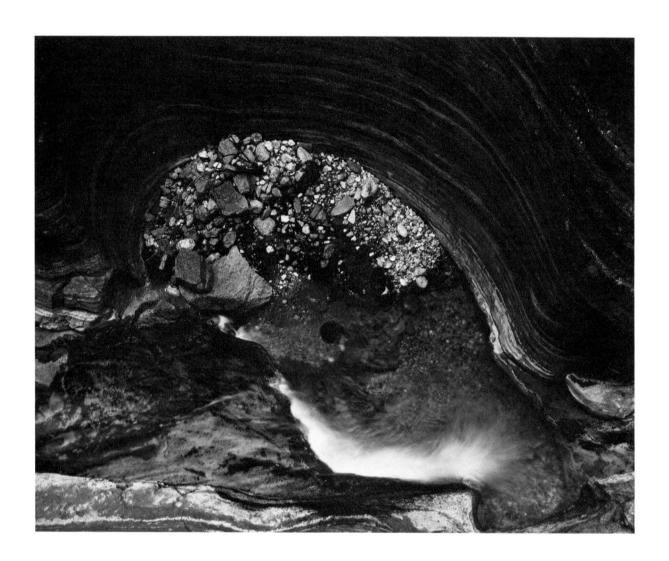

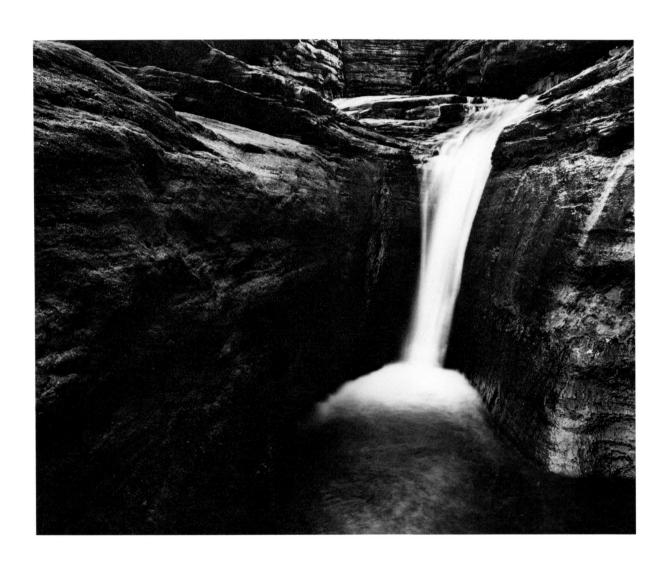

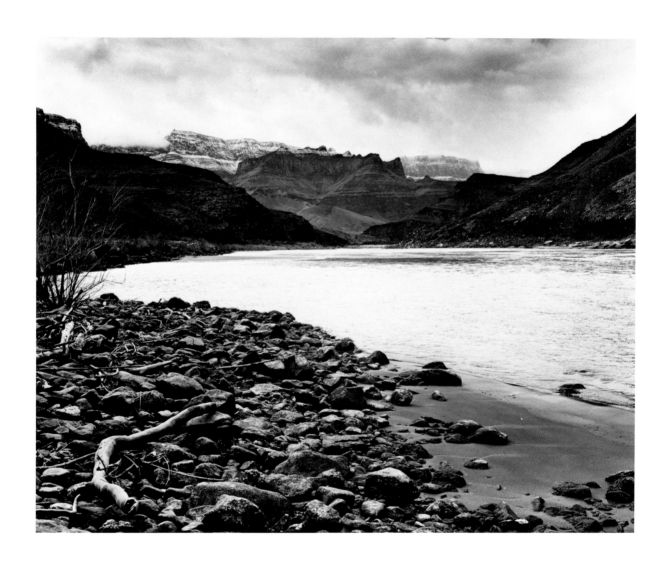

64

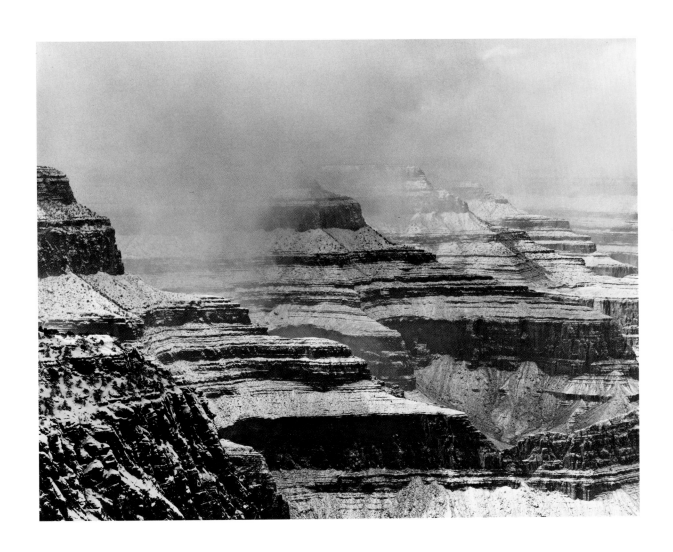

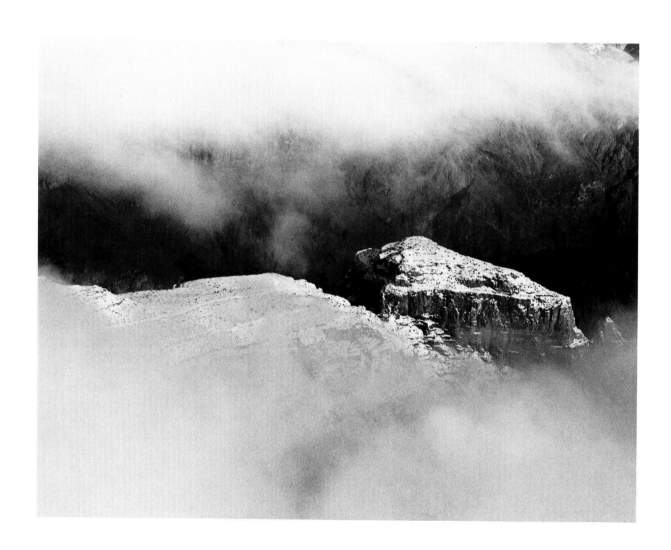

66

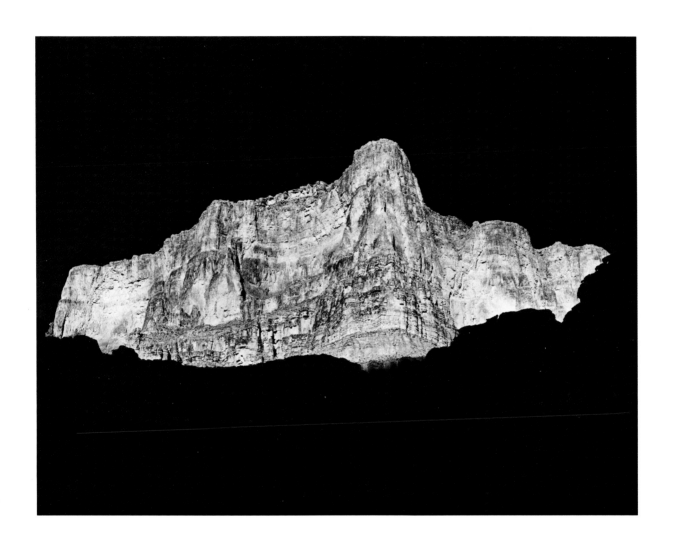

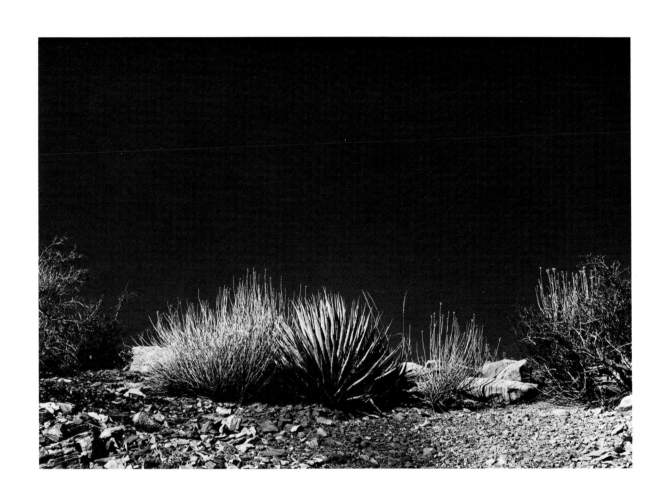

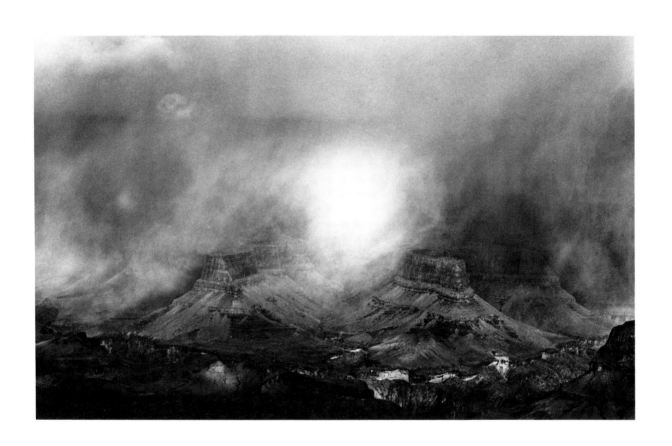

LIST OF IMAGES

The Enchanted Light, designed by Stanley Stillion, Rick Stetter, and Barry Thomson, was composed in Trump Mediaeval by Tiger Typographics, Flagstaff, printed on Quintessence Dull by Imperial Lithographics, Phoenix, and bound by Roswell Bookbinding, Phoenix.